Leonard Grigg

LONDON'S
EAST END
THEN & NOW

IN COLOUR

STEVE LEWIS

The
History
Press

Dedicated to
My wife Jan and my family for all their support,
and to Mum & Dad for my East End roots.

First published 2012

The History Press
The Mill, Brimscombe Port
Stroud, Gloucestershire, GL5 2QG
www.thehistorypress.co.uk

British Library Cataloguing in Publication Data.
A catalogue record for this book is available from the British Library.

ISBN 978 0 7524 6430 5

Typesetting and origination by The History Press
Printed in India.
Manufacturing managed by Jellyfish Print Solutions Ltd

ACKNOWLEDGEMENTS

I am grateful to the following for their valuable contribution to this project:

To Caroline Compton who spent so much time helping me with the research for this book and who has written the text to go with my photographs.

To the *Newham Recorder* for giving me the freedom to express myself with my camera in the 1960s, and the editor, Tom Duncan, who had the foresight to see the changes that were happening in the East End.

To my close friend Geoff Compton who was news editor of the *Newham Recorder* and who wrote the text for my 1960s book.

To all at Newham New Deal Partnership (Newham NDP) including Jessica Wannamaker, Howard Mendick and Anita Blow.

To Jenni Munro-Collins at Newham Archives for her help with researching photographs.

To photographers Steve Poston and Andrew Baker for their assistance.

To Victoria Grant for the photographs recording the construction of the Olympic Stadium.

To Westfields Stratford and Greg Fonne.

To West Ham United Football Club and Greg Demetriou.

To Dipika Kulkarni and all at Providence Row.

To Martyn Goody for his invaluable help with Photoshop.

Steve Lewis can be contacted via his website – www.stevelewisphotography.com
He is represented by Getty Images www.gettyimages.co.uk

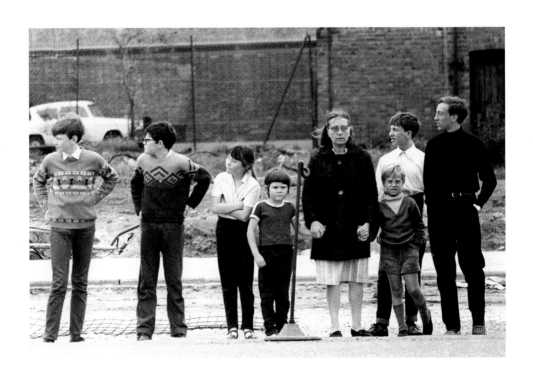

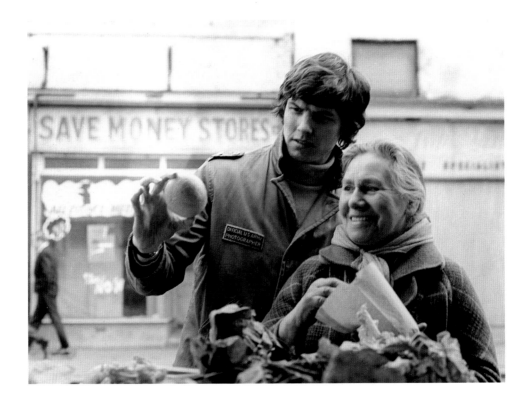

INTRODUCTION

The photographs in this book contrast the reality of life in East London half a century ago with the area and its residents today. Throughout the 1960s and early '70s I was a press photographer covering this part of London and took many emotive pictures which portrayed the East End during that era.

Despite the wonderful Cockney humour, my overwhelming memory of those days is of deprivation and poverty. Many families were on the breadline or even destitute, while housing was too often inadequate and thousands of children were underprivileged.

The Second World War had been over for at least 15 years but much of the evidence remained, with bombsites still littering the East End and some families incredibly still living in wartime huts.

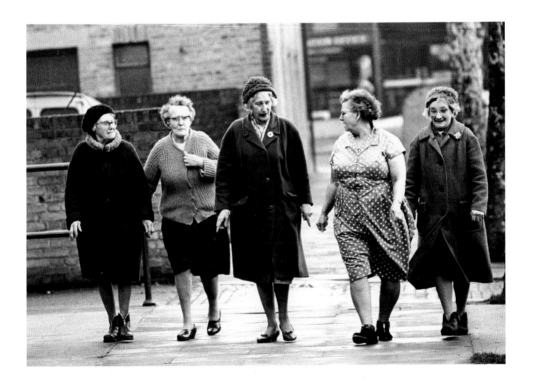

My first book, *London's East End: A 1960s Album* featured a selection of my old black and white photographs which captured the spirit of the people and their way of life during that era. Now, around half a century later, I have revisited many of the locations I knew then to take up-to-date photos – and in many cases, it wasn't easy to identify them. Since the area was chosen for the site of the 2012 Olympic Games, demolition and new building has been ongoing and the regeneration of East London is a magnificent sight and achievement.

The railway sidings in Stratford, for example, no longer exist. In their place is the brilliant Olympic Stadium complex and new shopping centre. And the area around the Royal Docks, once mainly derelict wasteland and a magnet for the homeless, has been transformed into a thriving administration centre and smart residential area, overlooked by London City Airport.

I discovered other things had changed too, like the pub I couldn't find because it had been rebuilt further down the road, and the outdoor markets that had disappeared under cover. In one of those markets I was amazed to meet a stallholder still plying his trade who I'd photographed in the 1960s!

Much of the East London I knew half a century ago is almost unrecognisable now and I was fascinated by the changes during my memory lane visits to the area. I hope the pictures in this book are successful in capturing the East End as it was then and as it is now – and show you what a wonderful part of England's capital it is.

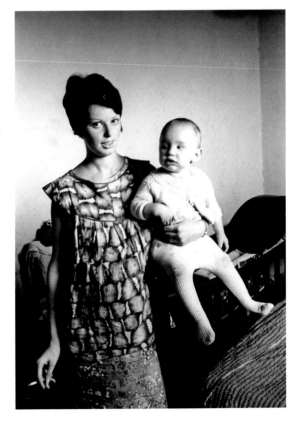

STILL WATERS

IN THE 1960s the docks saw labour relations hitting a new low. They had been in decline since the Second World War with strikes often bringing the Port of London to a standstill, and I was a regular visitor to the area to report on the latest troubles.

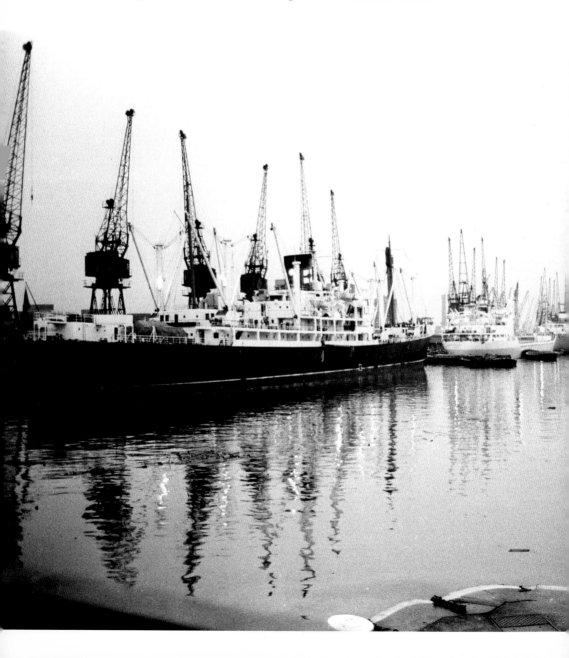

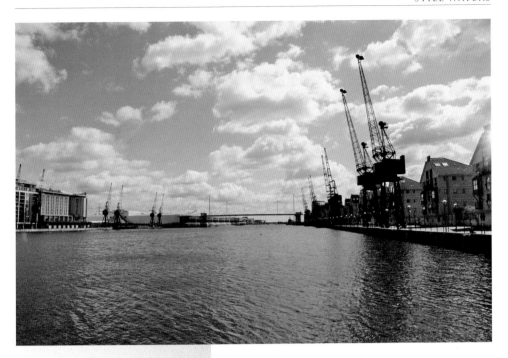

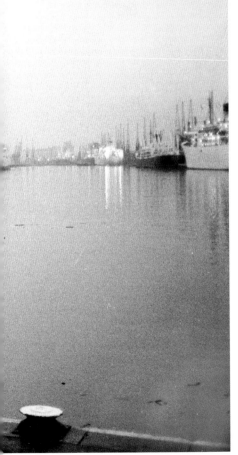

Now, the whole area is a revelation. The road down to the docks at the junction of Silvertown Way and Tidal Basin Road looks much the same until you reach Western Gateway running alongside Royal Victoria Dock, once the hub of the Port of London shipping.

I wonder what the old dockers would think today of the stunning waterfront with its trendy shops and restaurants, smart offices and residential properties. The big ships have been replaced by rowing clubs and it's the home of the Royal Victoria Docks Watersports Centre. Further down the road is ExCel London, an international exhibition and convention centre opened in 2000.

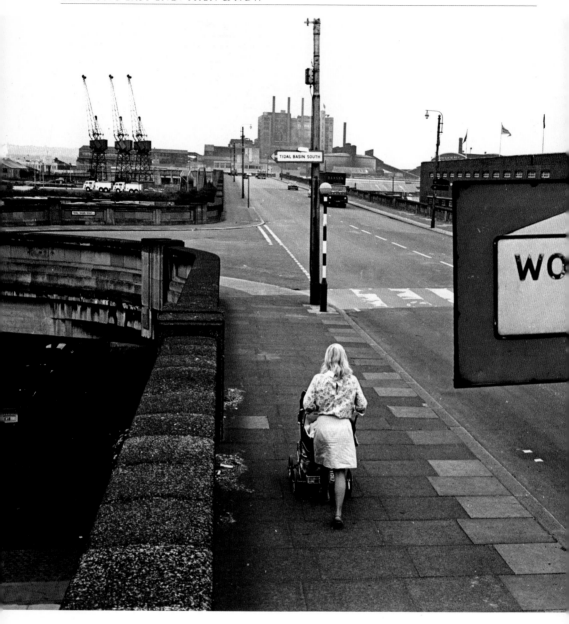

We see the massive factory of Tate & Lyle in the background in this 1960s Docklands shot, but today the area has undergone vast changes. While the road to Woolwich has not changed much (see opposite bottom), the Tidal Basin Road transports you into a new world at Western Gateway.

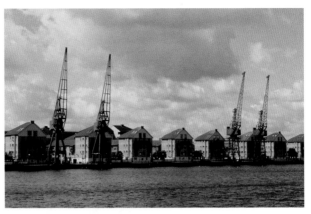

Ships and dockers have given way to luxury apartments, but the heritage of the docks is remembered in a statue in front of the ExCel.

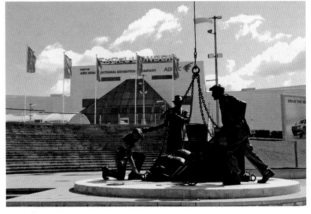

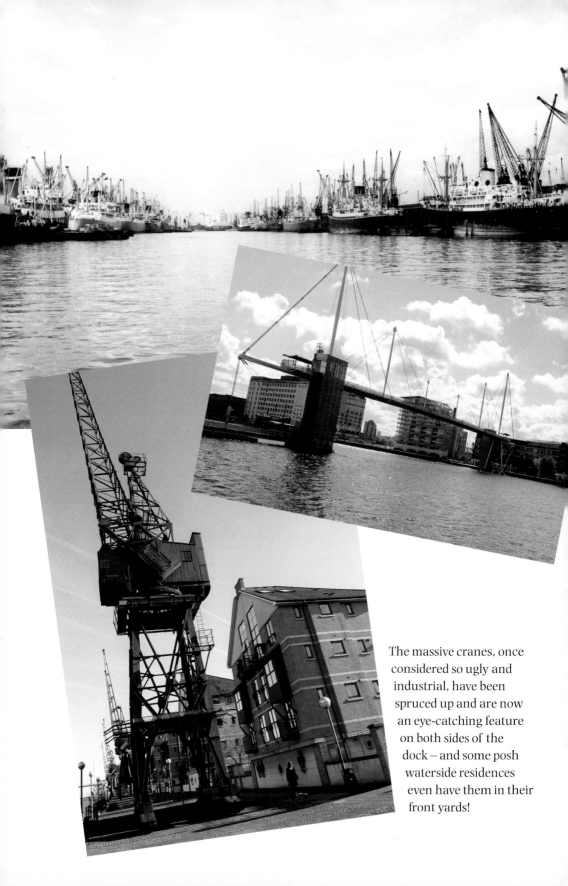

The massive cranes, once considered so ugly and industrial, have been spruced up and are now an eye-catching feature on both sides of the dock – and some posh waterside residences even have them in their front yards!

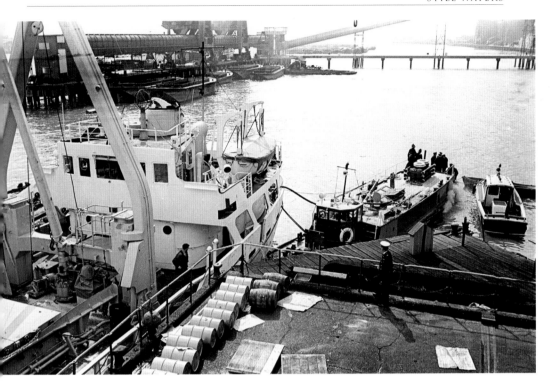

he ships and cargo have gone, to be replaced by big business, new homes and infrastructure.

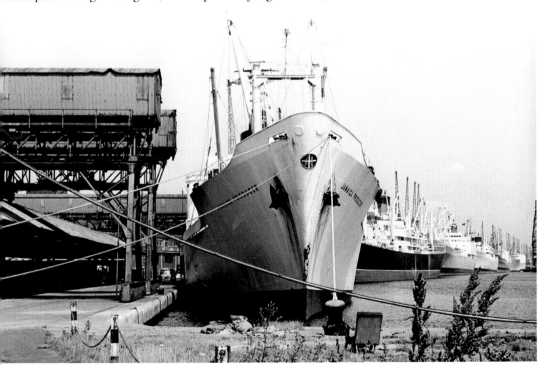

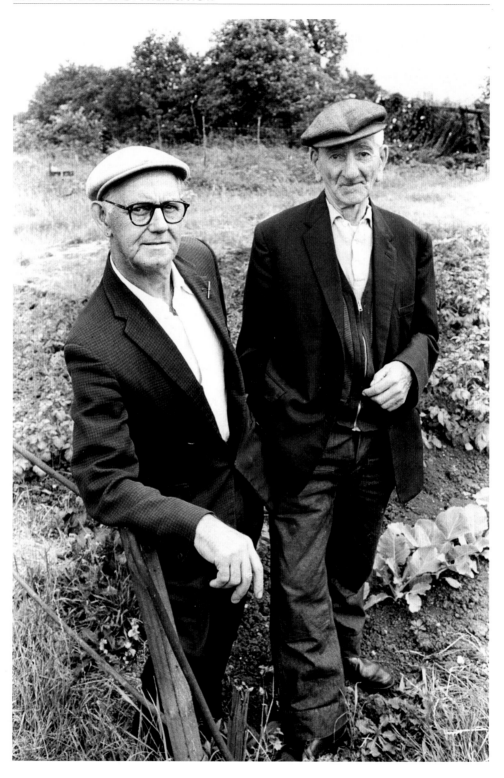

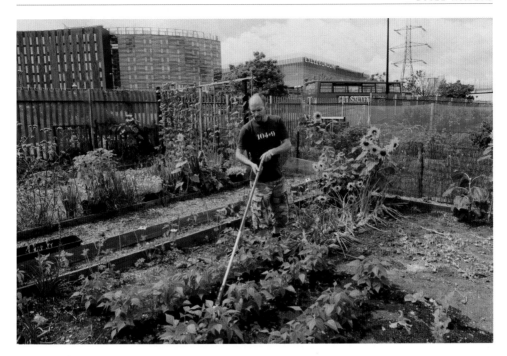

I took pictures of some locals in the 1960s working on their allotment plots by Leyes Road, in the shadow of the looming dockside cranes. I never imagined the allotments would still be there after all the regeneration in the area, but they are, now towered over by the ExCel Centre and a huge hotel complex which have been erected between the allotments and the waterway. The allotments, too, have had a makeover and are now surrounded by smart railings with padlocked gates – a sign that even spinach and sunflowers are not safe from petty criminals these days.

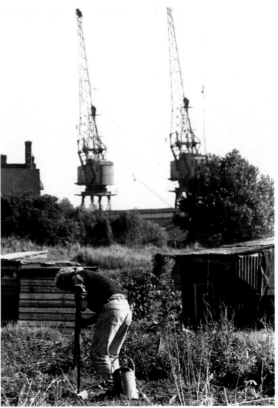

SWEETNESS AND FLIGHTS

A PLAN TO BUILD a single-runway airport in Docklands was first proposed in 1981 when the Royal Docks were finally closed to shipping, and regeneration was essential for the local area. London City Airport was opened six years later and in 1988, its first full year in operation, handled 133,000 passengers. Today it handles around 3,000,000, many of them business travellers.

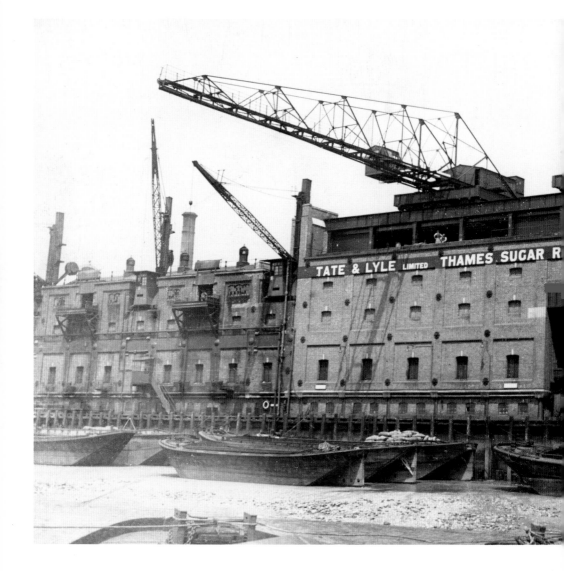

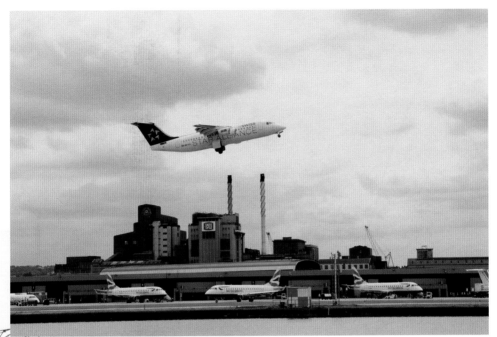

The runway runs alongside the Royal Albert Dock and looming over it is the immense Tate & Lyle Thames Sugar Refinery in Silvertown – an iconic East London landmark since it was built by Henry Tate & Sons in 1878. My photographs show the refinery as seen from the River Thames (left) and London City Airport taken from the council offices at Building 1000 across from the old Royal Albert Dock.

OLYMPIC PRIDE

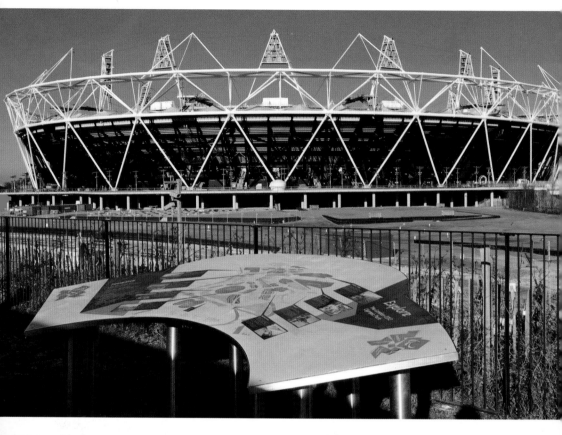

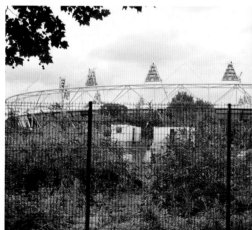

THE OLYMPIC STADIUM stands proud and magnificent, an architectural masterpiece of the twenty-first century hovering like a massive spaceship above the landscape. But just a stone's throw away are overgrown wastelands, bombsites and pre-war factory buildings hidden from the sight of visitors to the games. Since the area was chosen for the 2012 Olympics, dozens of buildings have been demolished and sites cleared to make way for the stadium. My picture of the towering arena was taken from a factory site in Wick Road which was originally designated to be demolished for car parking, but got a last-minute reprieve. The photographs here show how, little by little, the land was cleared and the magnificent stadium erected . . . and some of the wild and derelict wasteland that still lurks in its shadow (opposite, bottom right).

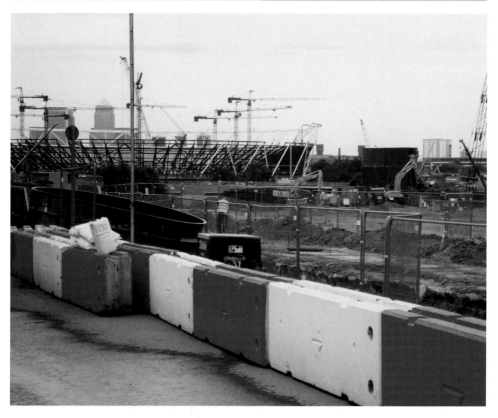

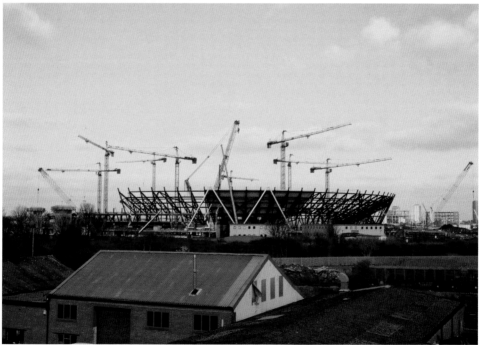

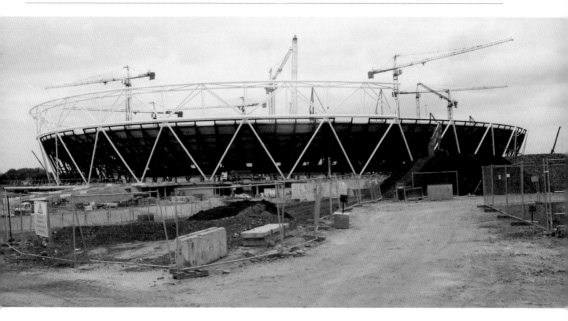

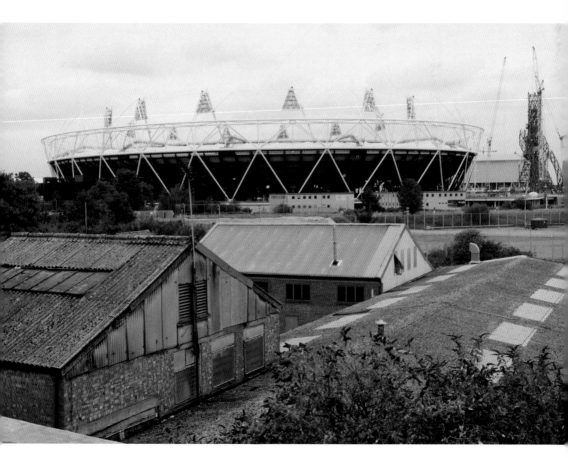

STRATFORD HIGH STREET

AS A PHOTOGRAPHER IN THE EAST END I covered many road crashes and when I came across this old picture of an accident outside the Yardley factory in Stratford High Street, I went back to the location to see what it's like now.

The 1937 art deco Warton House, known locally as Yardleys, was always one of the most famous buildings in East London. The perfume manufacturer's name was on the wall above a beautiful coloured mosaic of a woman and two young girls carrying baskets of lavender.

Warton House, which is a listed building, is now dwarfed by modern multi-storeys close to the Olympic Park and is encompassed in a new site of residential blocks, a hotel, restaurant and retail units with landscaped gardens leading to the Olympic Village.

Yardleys left the building in 1966 and its name has disappeared but it was good to see that the lovely Lavender Girls are still part of the local scenery.

23

TOTTERS

BACK IN THE 1960s, rag and bone men with their carts and horses were a common sight up and down the streets of the East End. Known as Totters, the men used to keep their horses in several stables in the area, like Mother Brett's Yard in Leyes Road, Custom House (overleaf), where I took pictures on a wintry day.

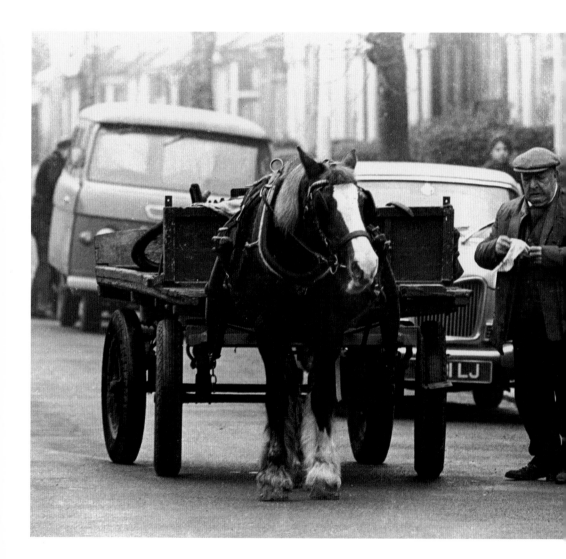

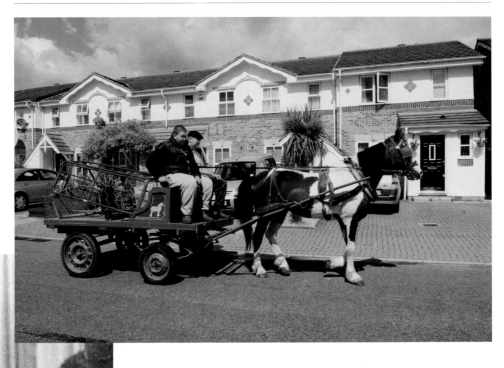

Totters still do the rounds in Custom House, a stone's throw from Mother Brett's Yard.

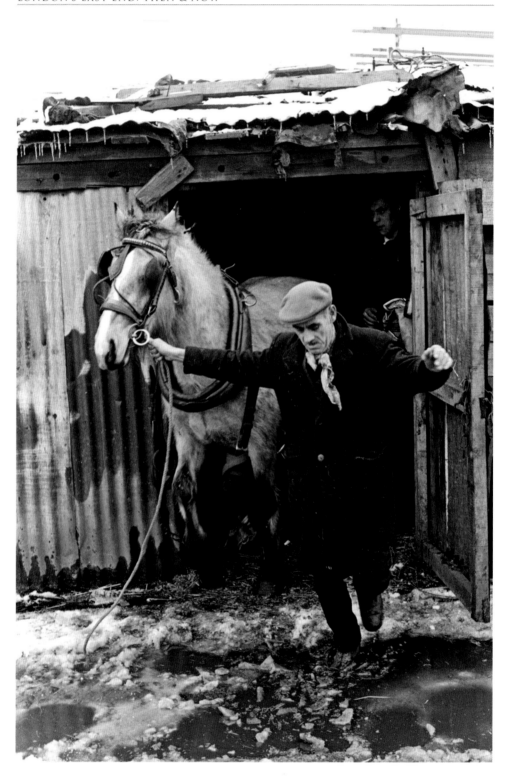

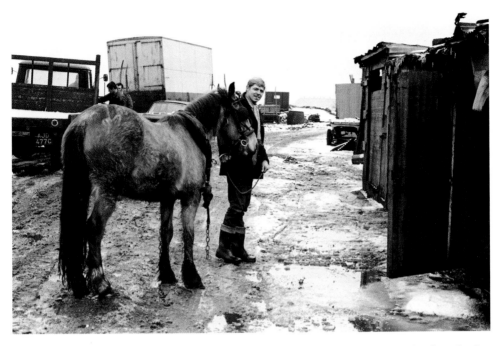

Fifty years later I returned to Leyes Road to find the stables are still there, a few hundred yards down the road from Mother Brett's Yard which is now the site of a school. The Stansfield Road stables look a lot smarter and tidier than the old ones and there's still a cart or two around, just like the old days.

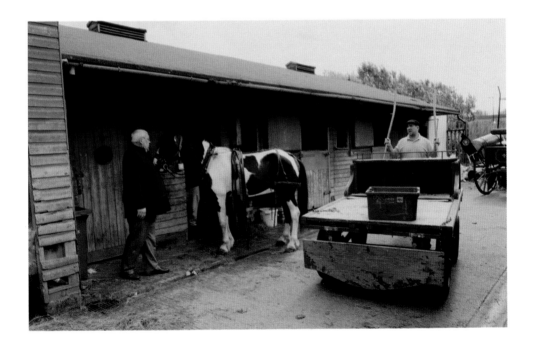

TIME TRAVELLERS

GYPSIES AND TRAVELLERS were always a problem in the 1960s and I regularly went down to their campsites to take photographs when there was some dispute or other. I remember being really shocked at the squalor and insanitary conditions they lived in, like drinking contaminated water which was a serious health threat.

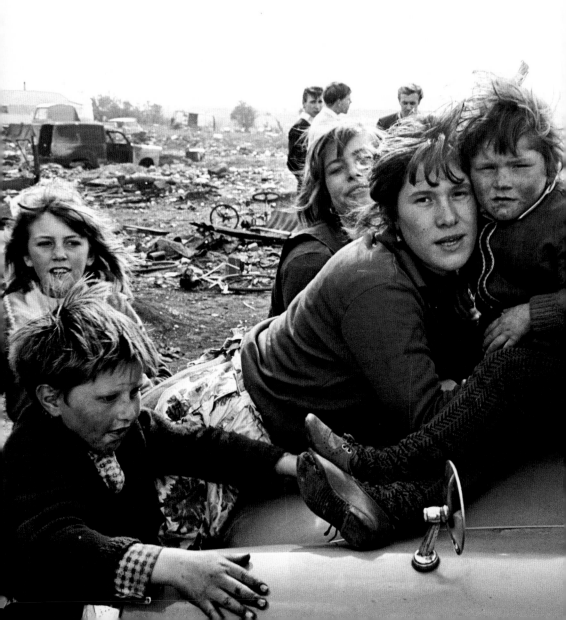

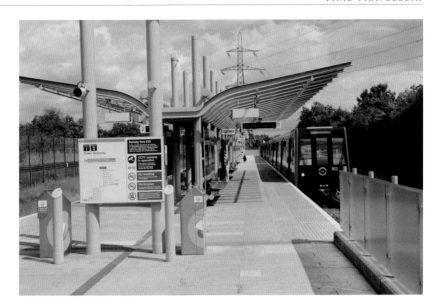

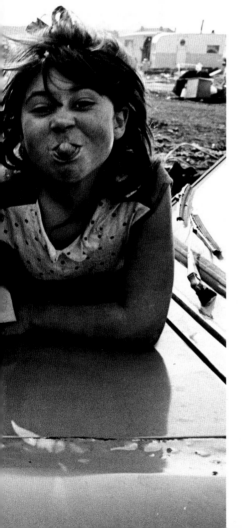

In the late 1960s, lots of families had made their home on a site in East Ham known as Beckton marshes, and the council was fighting to have them moved on. The gypsies wanted to be given a permanent site and local residents were often up in arms because they didn't want them living close by.

I couldn't believe the change in the area when I went back 40-odd years later. The Docklands Light Railway took me straight into the modern and landscaped retail park – a far cry from the terrible sights I saw and the appalling way the gypsies lived on the same spot back in the 1960s.

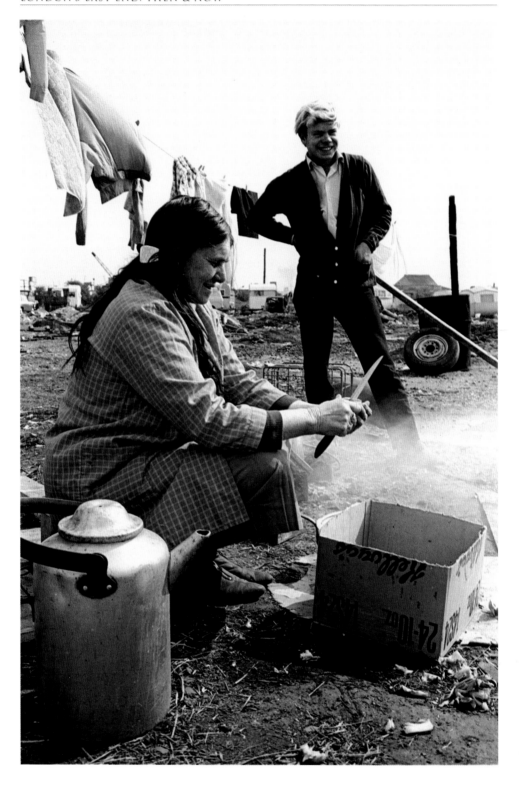

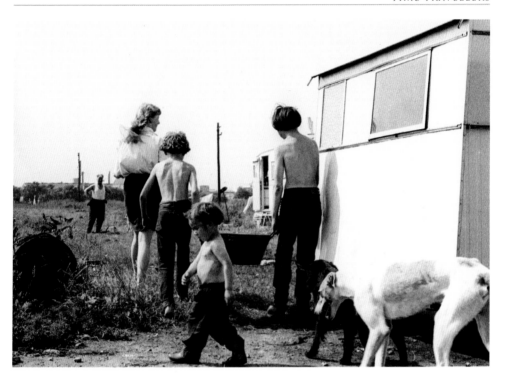

On the site that gypsy families once called home, there is now a retail park with a superstore situated between Tollgate Road and Woolwich Manor Way.

AS TIME GOES BY

THE OLD-TIMER didn't miss much as he sat watching the world go by. As long as the weather was fine, you'd find him in his wheelchair on Vicarage Lane most days. But back in the early 1960s, he never saw a woman wearing trousers . . . or carrying a plastic shopping bag. And as for her mobile, he probably didn't even have a phone at home in those days.

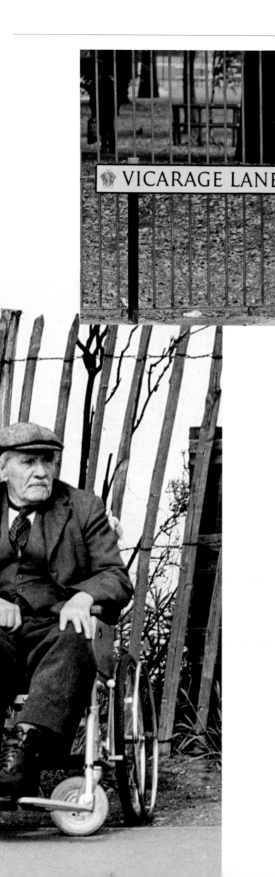

THE LAST HUTS STANDING

IN JUNE 1969 I went to Bridge Road in Stratford to see the last remaining Nissen huts in the area. Near the end of the Second World War, families had been told they would be living in the tiny prefabricated homes for only a couple of years – but here they were 25 years later.

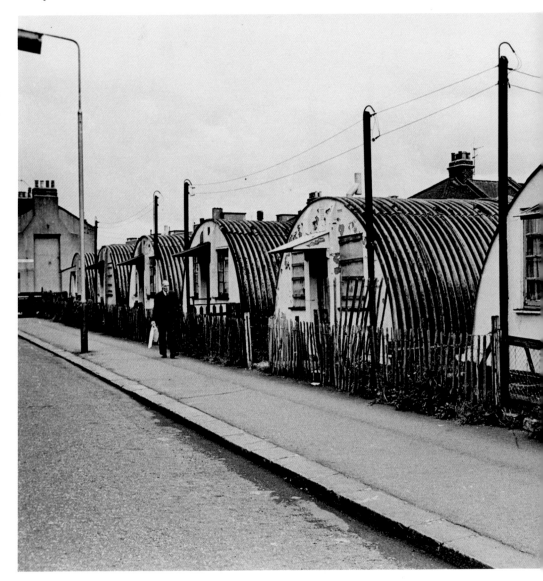

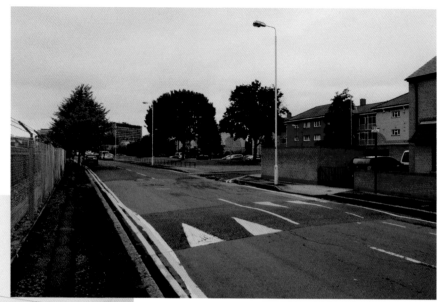

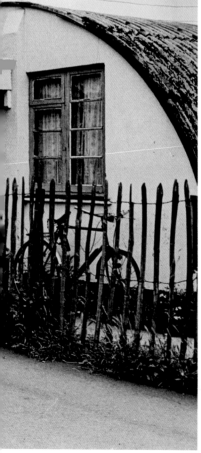

The East End had been horrifically bombed in the war, being a key target for the Luftwaffe because of the docks. Whole streets were obliterated and many survivors who lost their homes were rehoused in the Nissen huts which were quickly erected all over the area, many by Italian prisoners of war. When I returned recently, the top of Bridge Road now runs parallel to the new Stratford railway development and there's a school playing field and housing development where the old Nissen huts used to be.

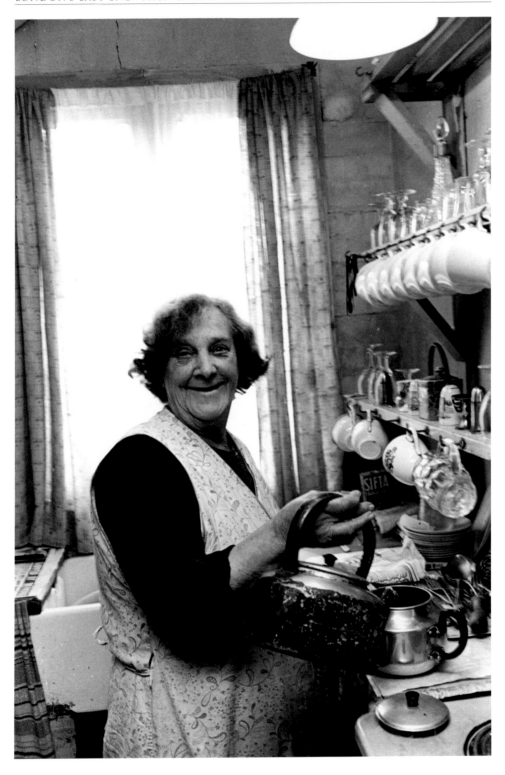

In the 1960s, I met people still living in the corrugated asbestos huts and listened to the stories of how their homes had been destroyed by German bombers and they'd had to move into their 'temporary' accommodation. Widow Caroline Moore, 76, had been bombed out of her house in Paul Street, Stratford, and had been living in her Nissen hut ever since. I remember her inviting me in and making me a cup of tea.

These places were only meant as short-term homes and it seemed incredible that people, especially the elderly, were still living in them a quarter of a century later.

The living accommodation was cosy but extremely basic and the huts were really hot in the summer and very cold and damp in winter. But Mrs Moore wasn't complaining.

'So much has happened to me here that I'd be sad to leave. My old mother died here when she was 96,' she told me. 'Your home is as you make it and this is my home.'

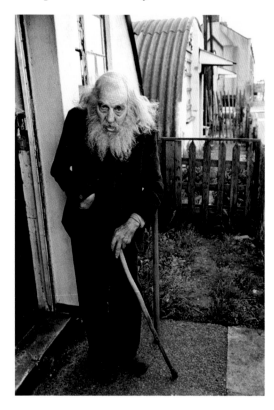

At that time there were seven Nissen huts left in Bridge Road and four of them were still occupied. Next door to Mrs Moore was Charles Mears, who was 70. He was a well-known artist in the area and lived in his hut surrounded by his paintings and drawings. But he was crippled with arthritis and had difficulty getting around. I remember him saying it was a good job he didn't have a house with stairs because he couldn't have managed them.

Of the 1,034 Nissen huts built in Newham during and just after the war, those in Bridge Road were the last standing and looked very dilapidated and tatty. And following the publication of my pictures at the time, the council's housing department promised there were plans to clear the huts and other poor property in the area.

Above: Charles Mears outside the front door of his 'temporary' home.

Opposite: Mrs Caroline Moore brews up in the kitchen of her Nissen hut.

PARTY POLITICS

THIS GRAFFITI MAY BE 40-ODD YEARS OLD but some sentiments never change. The message could have been written today – although not on the same wall. The graffiti artist's dream in Eve Road has been pulled down and more useful bricks and mortar erected in its place.

BIRD'S EYE VIEWS

I CLIMBED TO THE TOP OF A NEW TOWER BLOCK on the Freemasons Estate to take this photograph of bomb-scarred streets. It's a view I will never forget. It was in the mid-1960s and I couldn't believe the area was still in such a dreadful state 20 years after the end of the war. To come out of your home and be faced with a bombsite that had once housed your neighbours, must have been soul-destroying. Every day people were still being reminded of the terrible horrors of the war and the friends they had lost.

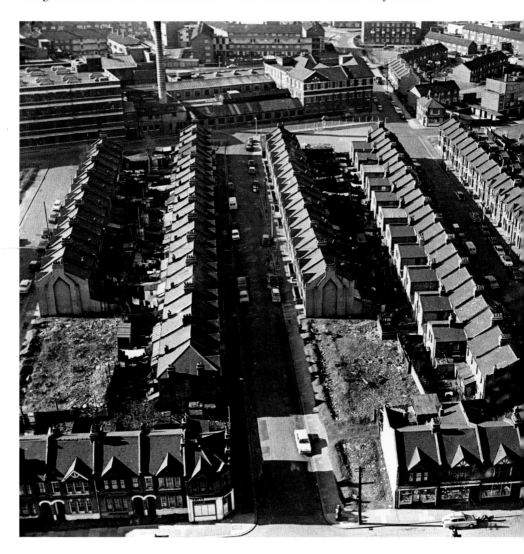

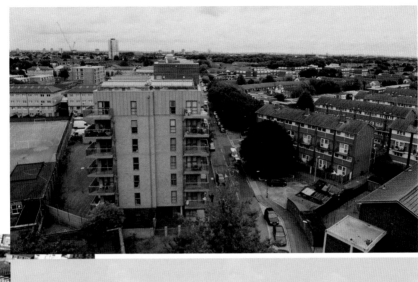

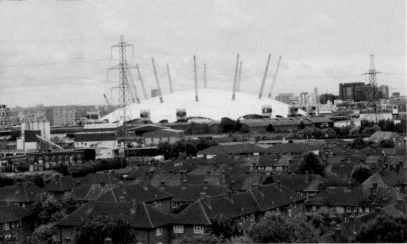

When I went back to see how it had changed, like so
many other areas of East London, I didn't recognise it.
A massive redevelopment had taken place. This time,
I climbed to the top of a block of flats at the corner of
Munday Road and Butchers Road – which is in the
foreground of the 1960s picture. People living here today
will probably be amazed to see how this area once looked
before the new estates popped up, at last erasing all
evidence of the disfigured streets and bombsites.

While I was up there, I looked around and saw the O2
Arena, once the much-maligned Millennium Dome,
nestling amid the rooftops. Such a fabulous sight!

GATEWAY TO HEAVEN

THE CINEMA on the corner of Stratford Broadway and Chant Street was known as the Picture Palace when silent movies were first shown there in 1910. Its name was changed several times and it became the Empire, the Imperial Playhouse, and the Plaza among others. Eventually, though, the old picture house had to give way to a new popular pastime and in 1969 the cinema was converted into a bingo hall. The bingo caller became a bit of a local celebrity, so when his 'Gateway to Heaven', number 27, finally came up, I was sent to take a picture of the funeral cortège passing by the bingo hall.

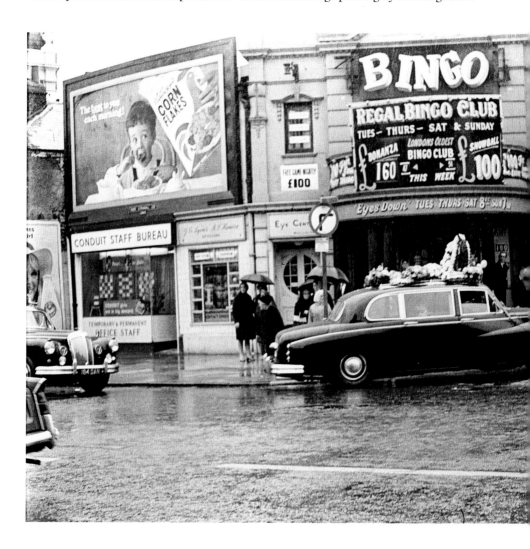

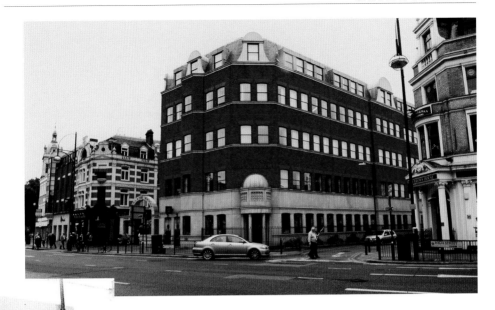

Now, more than 100 years since the original cinema was built, the street corner is unrecognisable. A smart new business centre, Gredley House, has replaced the dilapidated Edwardian buildings and proudly boasts that it's the best quality building in Stratford. And today's bingo callers would no doubt have fun with its 'Legs' 11 Broadway address too!

SLEEPING ROUGH
IN NEW SHOES

I CAN CLEARLY REMEMBER a night I spent with the homeless back in the 1960s. We were doing an article about tramps and vagrants and I went down to the Royal Docks to meet many poor souls who only cared about where their next drink was coming from. They spent all day and night on the bottle and by the time darkness fell, they were almost oblivious to the cold.

The homeless I met that night had no hope. Many were former Second World War servicemen who had become alcoholics. If they couldn't afford alcohol they would drink methylated spirits or even melted shoe polish. They stank, but they had no pride left to care. Whenever I see a homeless person on the street, I wonder about the men I met that night. I doubt they lived much longer.

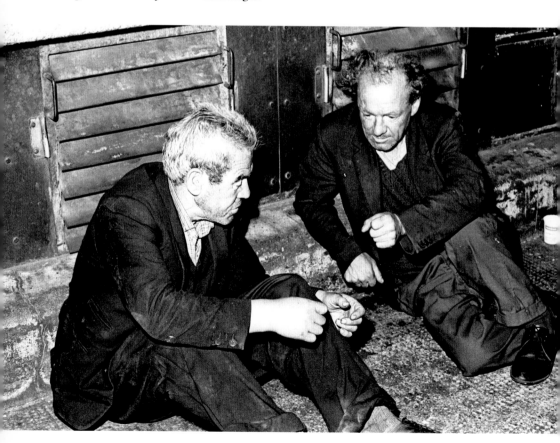

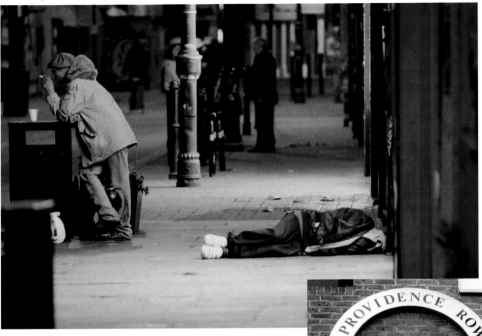

Sadly, whatever incredible, multi-billion pound changes have occurred to the East End in recent years, there are still homeless people on the streets. Tens of thousands of men and women are sleeping rough in London and many of them can be found in the East End. Today, though, there is a lot more help for these people and the charity Providence Row plays a huge part in helping the homeless get back on their feet in the area, offering everything from decent meals and washing facilities to help with addictions and mental health problems.

The guys pictured here are homeless but thanks to the clothes and shoes that are handed out, they are able to retain some of their dignity and hopefully sort out their lives – unlike the broken men I met all those years ago.

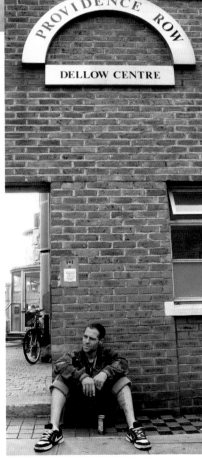

45

PLAYTIME

I WAS A REGULAR VISITOR to Manor Road Buildings in my job as a newspaper photographer. There was a story almost every week about this run-down residential area, usually based on complaints about the terrible housing conditions. Known locally as 'The Buildings', the four-storey blocks of flats were West Ham's first high-rise housing, built in and around Manor Road in the 1920s. The first tenants had been rehoused from the poorer parts of the area and thought they had moved to 'palaces' in comparison, but within a few decades the area had gained a really bad reputation.

I took one of my favourite photographs of a young lad doing his homework on the balcony of the flats where he lived in Star Lane. That block was demolished later in the 1960s and when I returned to the area recently I was convinced that all the flats would be long-gone and new housing built in their place.

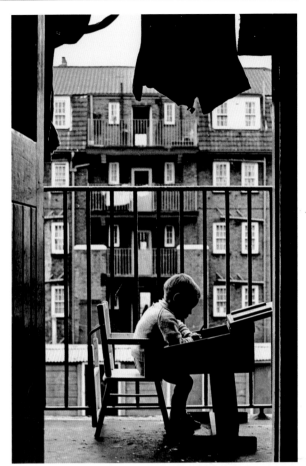

To my surprise 'The Buildings' have been completely renovated. There are gated entrances and the whole area has been smartened up. And the residents seem happy in their surroundings, with views of the new Memorial Park instead of the bombsite people used to look out on.

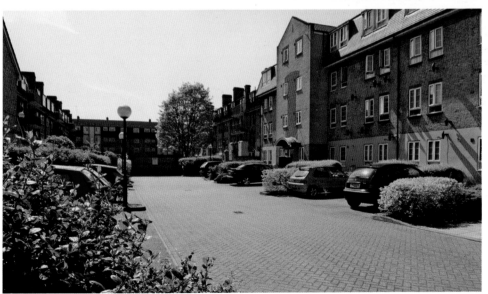

Back in the 1960s, children who lived in 'The Buildings' had little to do in the way of entertainment but play on the nearby bombsite and wasteland. The flats had no play areas or room for games. The graffiti-daubed wall, which stretched 180 yards along the wasteland by the side of the railway line, ironically informed us that this was 'Manor Rd Adventure Playground' and the kids created their games using whatever old junk was on hand for their adventures.

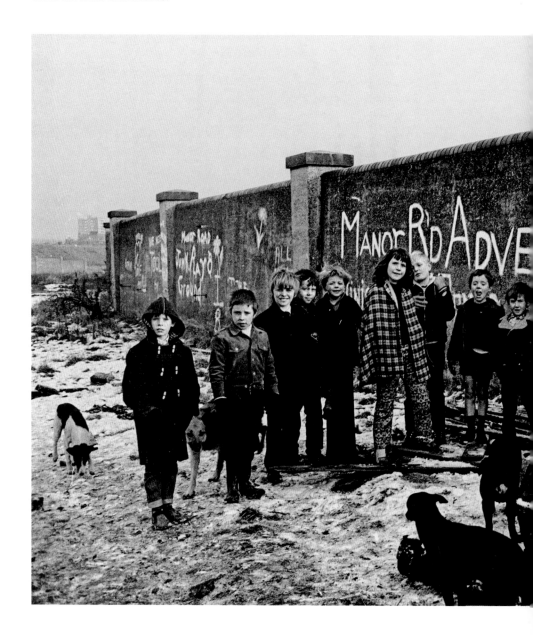

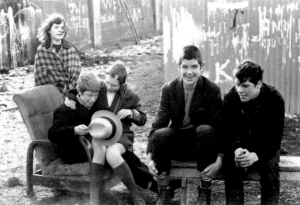

The long brick wall is still standing but is now a mass of colour – a fabulous mural depicting Newham's parks and sporting activities. It was designed by local artist Clem Richards and with the help of young and old in the community, it was completed in autumn 2007.

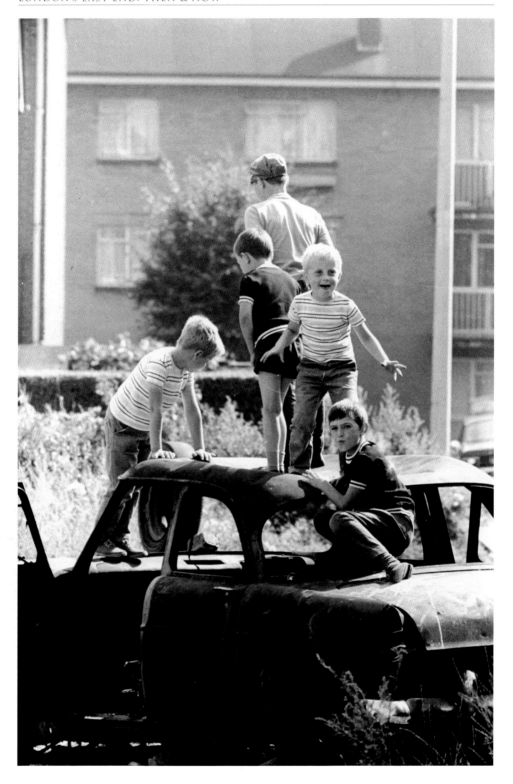

Half a century ago children happily built carts out of old pram wheels and spent hours playing in rusty cars that had been dumped among the rubbish . . . many perhaps with dreams of becoming the next Stirling Moss.

Decades later, I was delighted to see that the old play area is unrecognisable. The bombsite and wasteland have been totally transformed and in their place is Memorial Park, with a children's playground, playing fields and Grassroots, a community development centre which encourages locals to get involved in various activities.

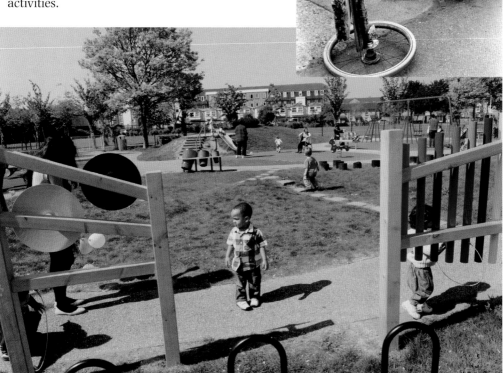

51

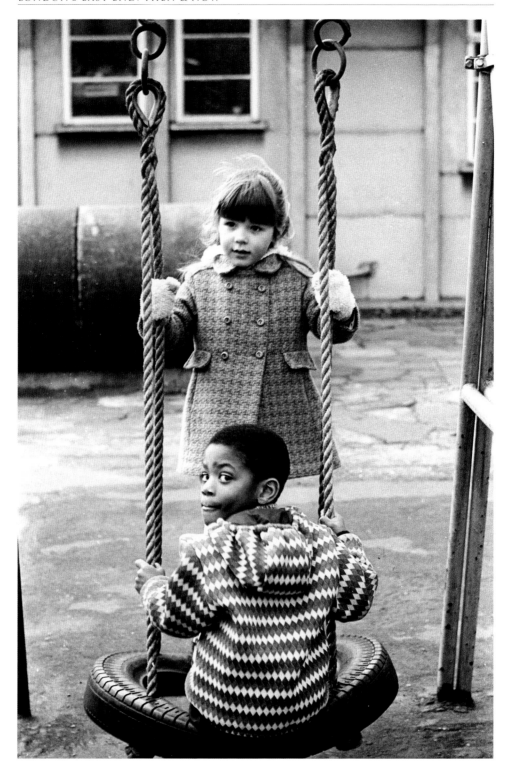

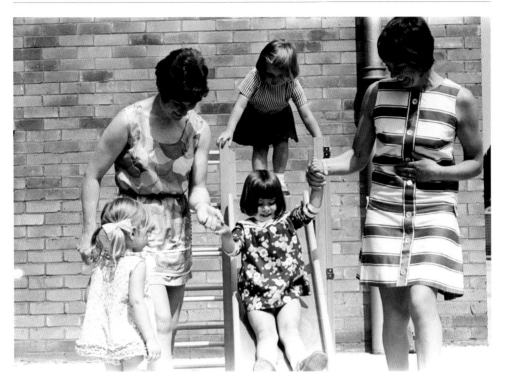

The play facilities might have changed for the better, but nevertheless these 1960s kids and their mums were enjoying the playground fun.

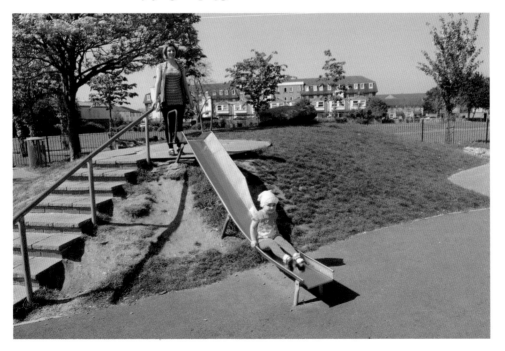

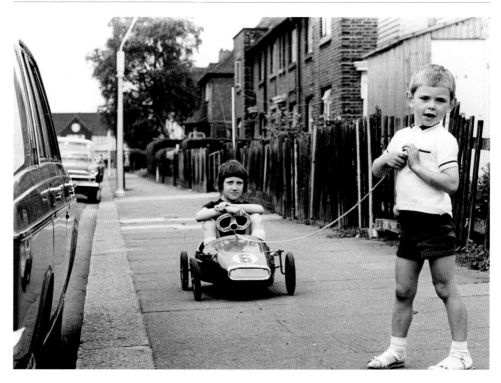

Who do you think you are? Stirling Moss? In those days, kids were free to roam without adult supervision and find their own entertainment.

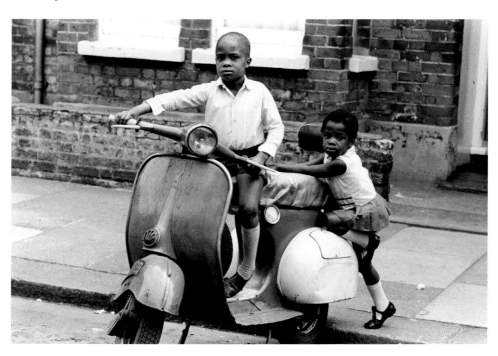

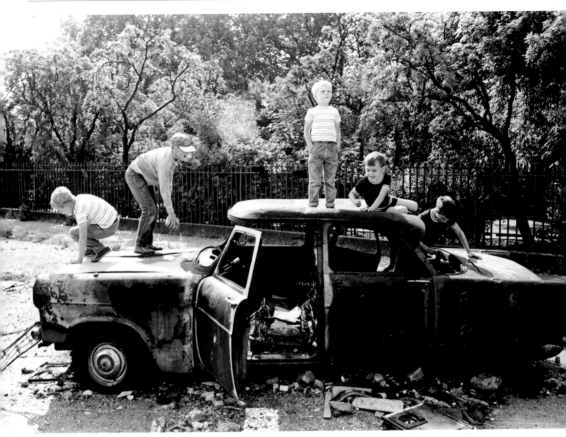

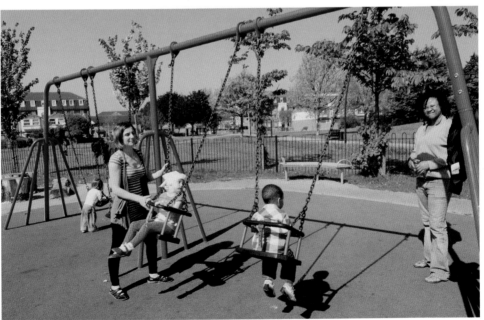

BYGONE BEAUTIES

EAST LONDONERS don't need much excuse for a knees-up and the Newham Town Show was always one of the main annual events. With its colourful, cosmopolitan atmosphere, it's as popular today as ever, and is still held in Central Park, East Ham, although it's now known as the Mayor's Newham Show.

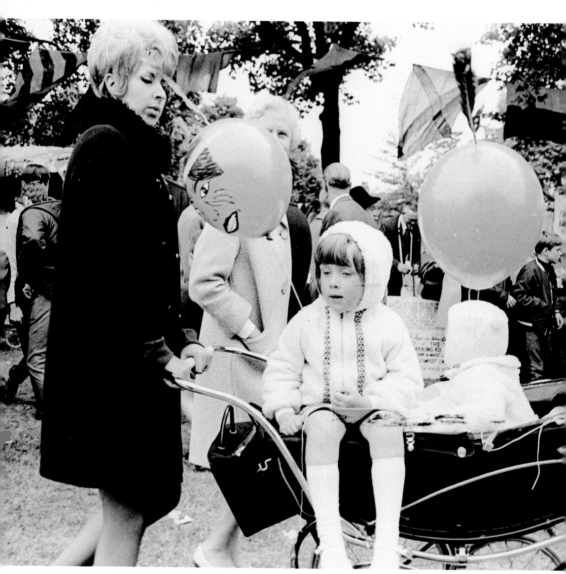

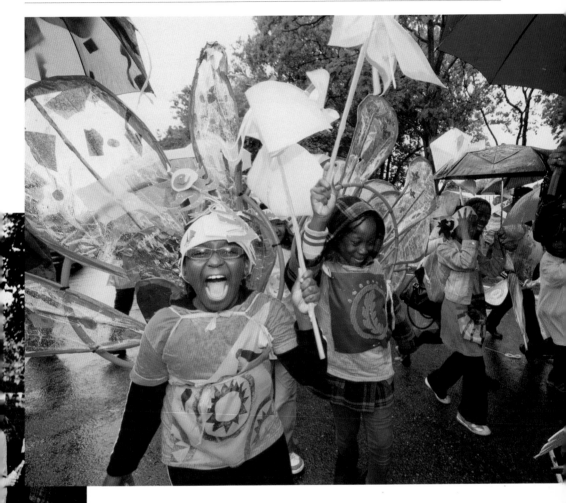

Children enjoy the carnival atmosphere of the Mayor's Newham Show in July 2011.

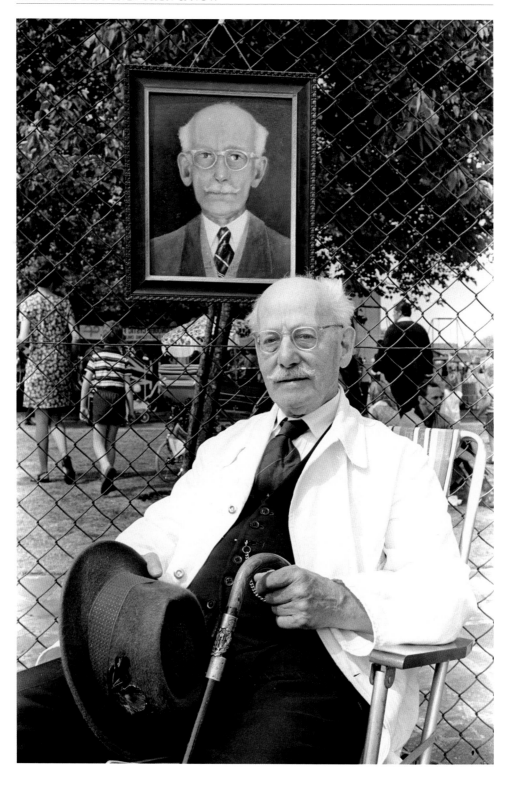

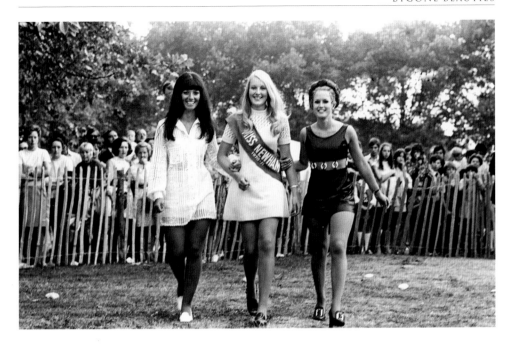

A favourite picture I took at Newham Town Show in the 1960s was of this distinguished gentleman showing off his artistic skills with a self-portrait. But he wasn't quite as easy on the eye as the lovely girls who entered the annual beauty competitions! The crowning of the Carnival Queen was one of the main events and girls from all over East London would take part, hoping to win the big prize and maybe make a career move into modelling. But criticism of beauty pageants and modern day 'politically correct' attitudes have killed off so many competitions like that, although the girls who took part in those days always seemed to love it and nobody had any objections.

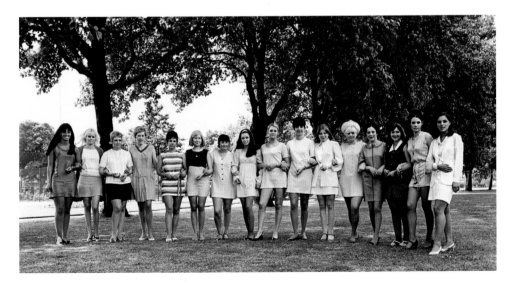

THE COST OF BLOWING BUBBLES

WHEN I CAME ACROSS SOME PICTURES I'd taken decades ago at Upton Park, I couldn't believe how cheaply we could get in to see a match. Just look at those prices – 90p and 70p or 18s and 14s in old money.

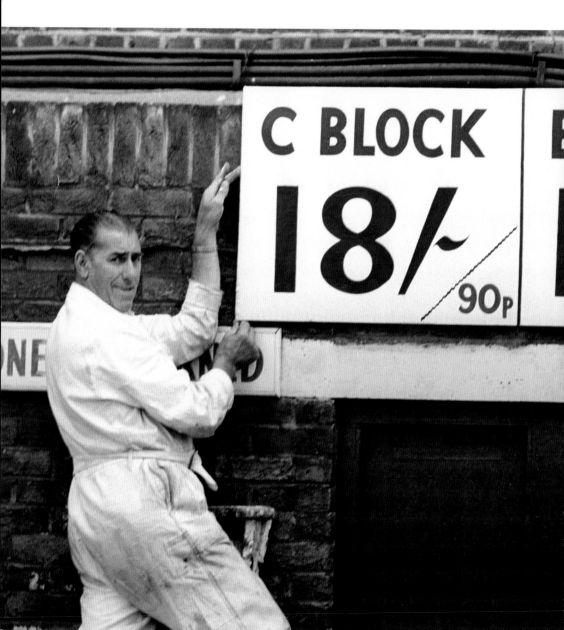

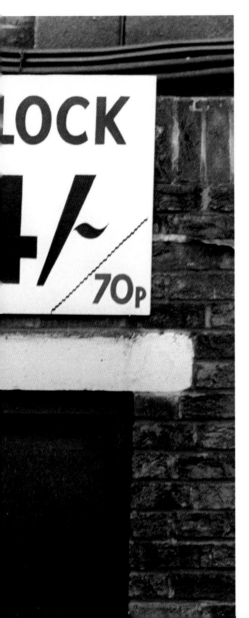

Decimalisation descended upon us in February 1971 and I went down to the West Ham ground to see how they were coping with the changes. One of the maintenance staff was nailing up a sign showing the new price alongside the old one, so nobody could get confused, but it would be a long time before we all got used to the new currency and forgot about £.s.d. The 90p it cost to watch the team then would be worth just a little under £10 today . . . really cheap when you consider what it costs now to get into a top-quality match. The general price for an adult ticket at West Ham for the 2011/12 season was £32.

Back in 1967, I took this picture of local lads queueing to get through the turnstiles for just half a crown. That's 12.5p in today's money and their dads only had to pay 25p – or 5s as it was then. In those days, fans were just as passionate about football as they are now . . . with one exception. In the 1960s picture, you'll notice that the tickets priced 2s 6d were for 'BOYS'. Girls didn't get a mention and women were certainly not big in numbers among the spectators. But these days, there are many girls and women at Upton Park and over the decades football has become a game for all the family to enjoy.

Below: Legendary striker Jimmy Greaves is filmed for a TV interview at the West Ham training ground. In 1970, Greaves (valued at £54,000) joined West Ham United in part exchange in the deal that took Martin Peters to Spurs.

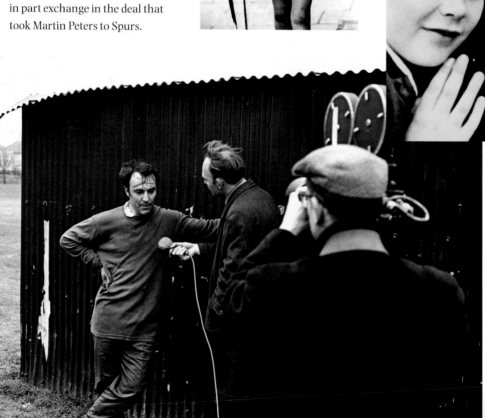

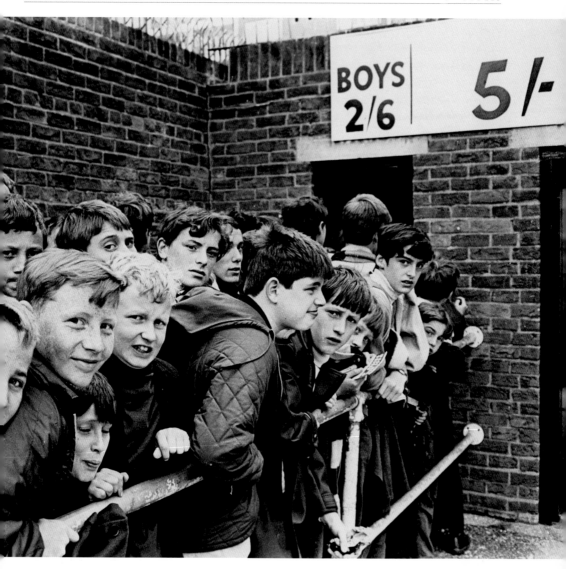

Above: West Ham lads queue to get into Upton Park in the winter of 1967.

Looking back at my old pictures, I'm quite moved by the eager young lads queueing up to get into the match, then getting engrossed in the game on the terraces. They look so innocent and excited and above all, patient. Mums didn't worry about their boys going to football on their own in those days.

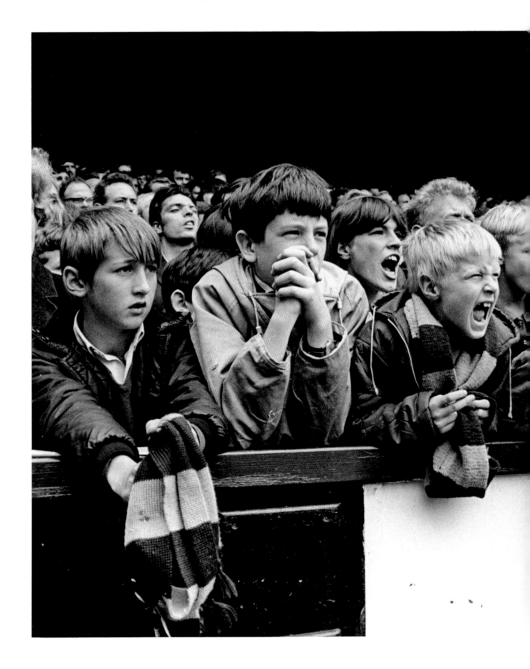

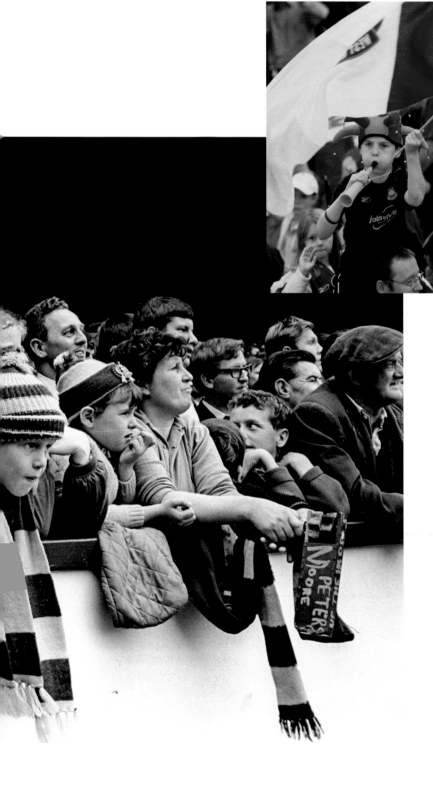

The police horse on duty at Upton Park (below) showed no fear of this group of youngsters and had no need for a visor over its face – a sad requirement for today's four-legged crowd controllers.

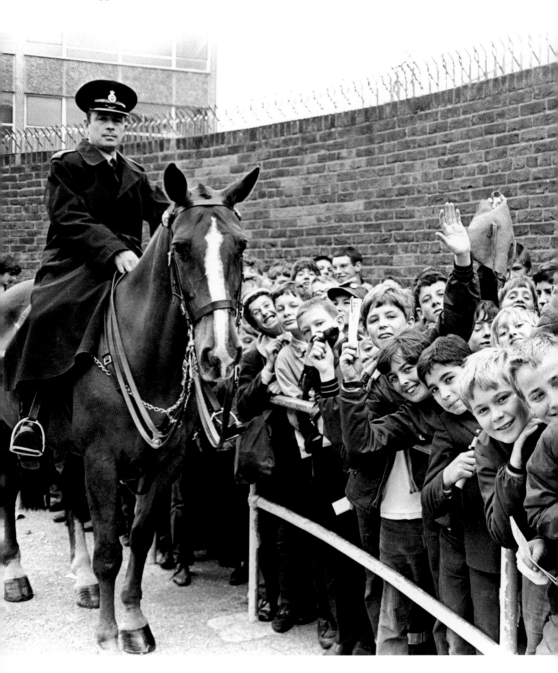

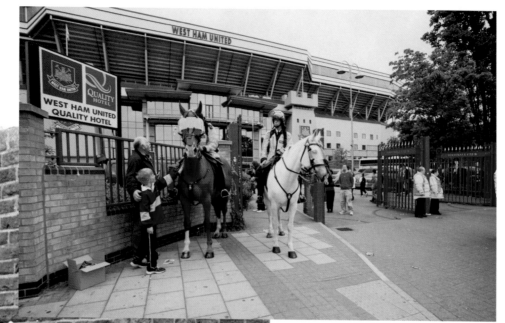

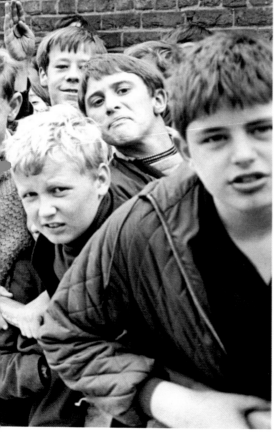

TIME'S UP!

IN THE MID-1960s, the spit and sawdust of East End pubs was getting a clean-up. Many of Newham's 176 pubs were being modernised – the bare floorboards, scrubbed wooden tables and old pianos were being cleared out and replaced by plastic and chrome fittings and jukeboxes.

But not all pub regulars were happy with the changes. Many East Londoners believed it was impossible to modernise the pubs without destroying their unique atmosphere. The dartboards and shove ha'penny games were as much a part of East London as jellied eels and barrow boys, and some pubs like the Queens in Forest Gate were determined to keep that heritage and the old character.

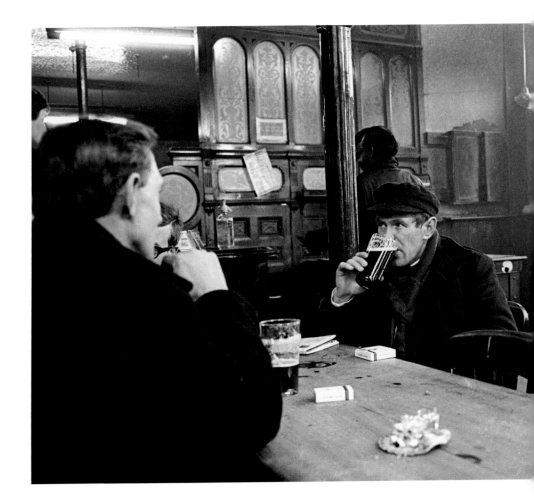

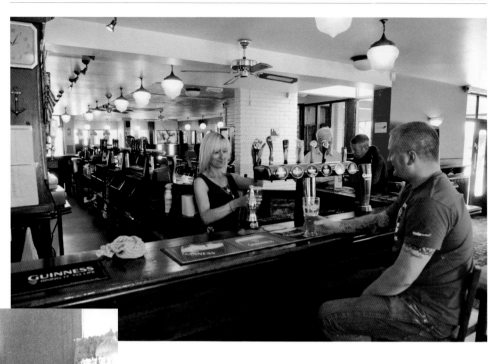

But eventually modernisation got its way and the Queens too, had to change. When I went back to take a look, not only had the pub undergone a complete transformation, but it was no longer there! It was pulled down in the late 1960s, probably not long after I was last there, and rebuilt further down the street next to Queens Road market. I thought it was a big improvement on the original but it still retains its classic pub character which the locals seem to appreciate.

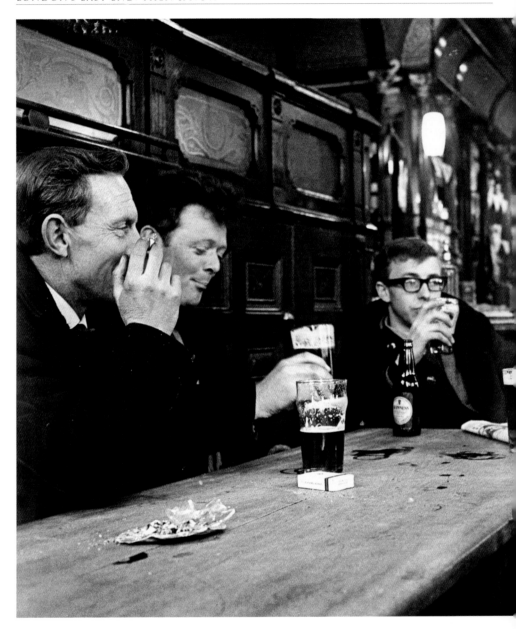

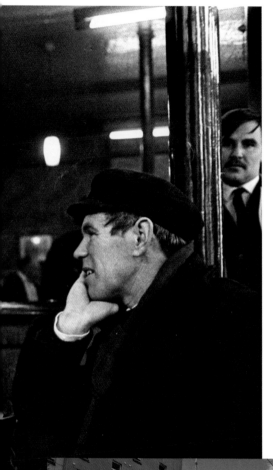

The Queens in Forest Gate was a typical East End boozer back in the 1960s – full of characters – but in the twenty-first century it has received a face-lift although it still offers great hospitality.

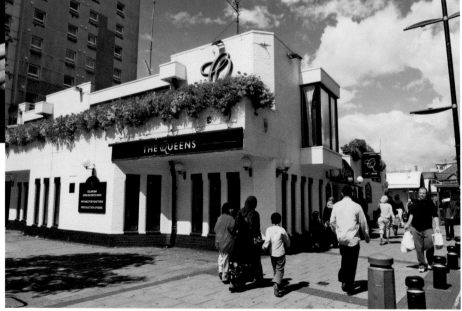

The Two Puddings in Stratford was a typical East End pub and was also known as the Butcher's Shop because of the occasional violent incident. The notorious Kray twins and their henchmen were regulars so there was sometimes a gangster-style shoot-out on the premises. Showbiz celebrities like the Small Faces were also regulars and you'd often see West Ham players and other famous sportsmen propping up the bar.

It was the only pub in the country called the Two Puddings and got its distinctive name around 100 years ago when the landlord used to give a slice of plum pudding to local pensioners at Christmas. I took a photograph outside the pub to accompany a story about another crime there, and was surprised when I returned to see the exterior looking much the same, although the name has been changed to Latin ¼ and it's no longer a gangster hangout but a cocktail bar and restaurant with plasma screens.

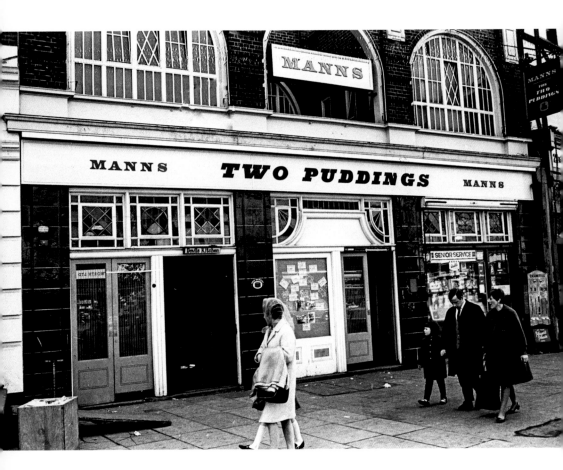

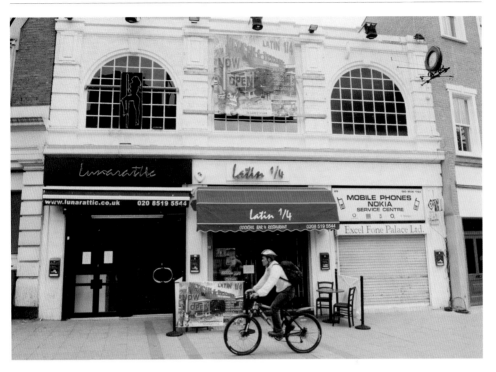

I still remember the day in the 1960s when I took the picture of two local characters outside the Duke of Fife in Katherine Road, Forest Gate. Rose Walsham, 73, and Susan Lawrence, 77, were arriving at the pub for their usual lunchtime tipple and asked me to join them. Mrs Lawrence had been a regular at the Duke of Fife all her life. Her mum had first taken her there as a baby in her pram and it was like a second home to her.

'There's nowhere like an East London pub,' she told me. 'At weekends we have a good old sing-song and the atmosphere in here has been the same for years and years.'

There were lots of other characters in the Duke of Fife including the old boys who could be found there every lunchtime playing cards in the corner. They were completely against their pub being modernised and never thought it would happen.

'The public will always want a "knees-up Mother Brown" type of pub like ours,' one old-timer told me and I remembered his words when I went back to take a look around. I found it all boarded up with a 'Sale By Auction' sign nailed to the wall. So who knows what will happen to the Duke of Fife now?

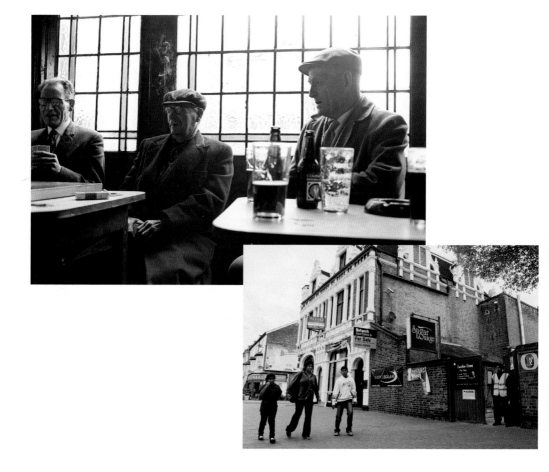

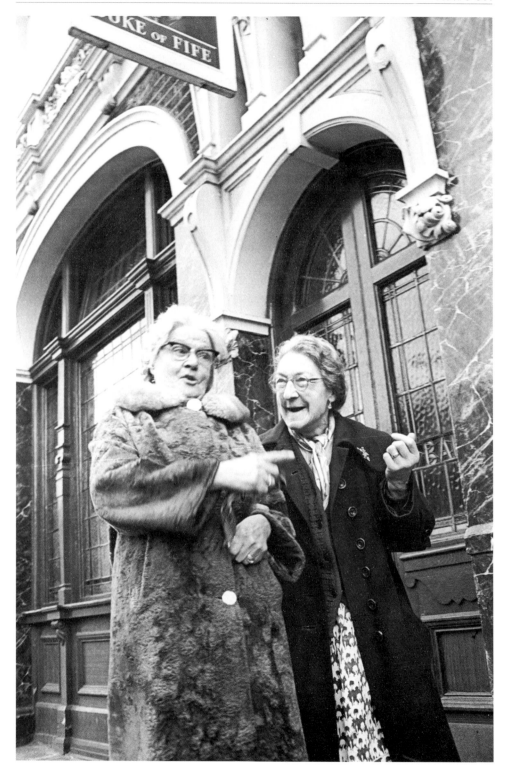

The most amusing pub picture I took was of a donkey called Bass having a pint in the Manby Arms in Stratford. I remember going to take a look after someone told me the landlord owned a donkey that lived in the yard behind the pub and which popped in for a pint every lunchtime.

Bass was originally called Toby but he didn't like Toby ale, so landlord John Loftus rechristened him when he took a liking to Bass with a drop of lime in it.

'He's not an alcoholic,' the landlord insisted. 'He'll have a pint if he's really thirsty but otherwise he sticks to halves!'

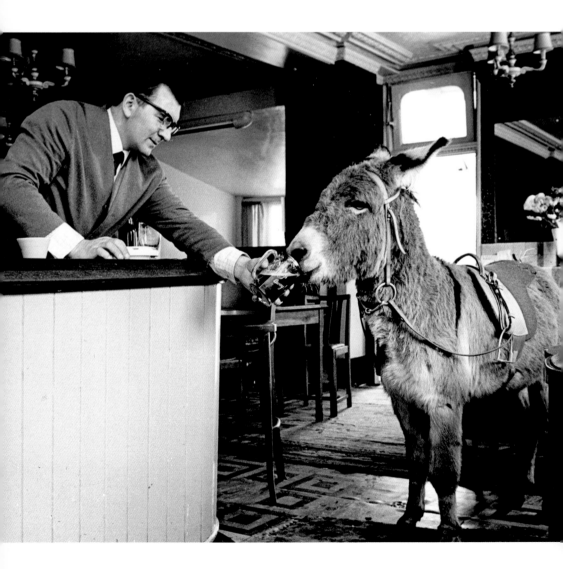

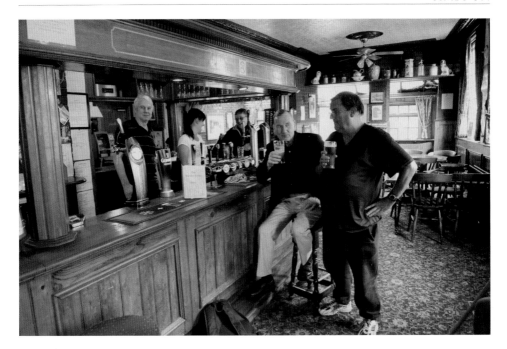

When I went back to the pub it was as though time had stood still. Outside it was
exactly the same, and apart from some refurbishment, the interior was unchanged.
The pub is still a favourite watering hole for East Enders and sitting at the bar where I'd
photographed Bass decades earlier were some locals who could actually still remember
him.

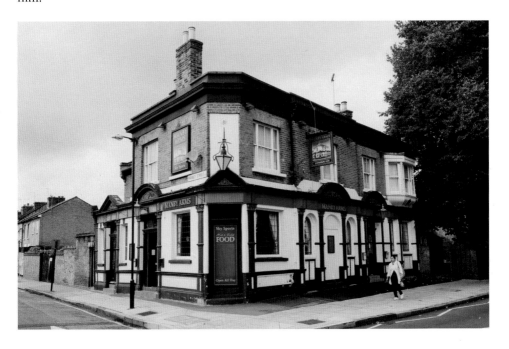

MARKET SURPRISES

MOST MARKETS THESE DAYS have escaped the elements and gone indoors but the wisecracking Cockney traders who've always been up for a quip, come rain, shine or freezing fog, never change.

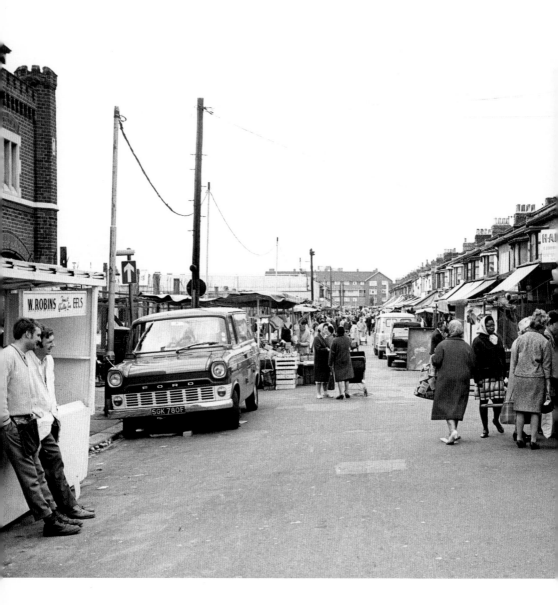

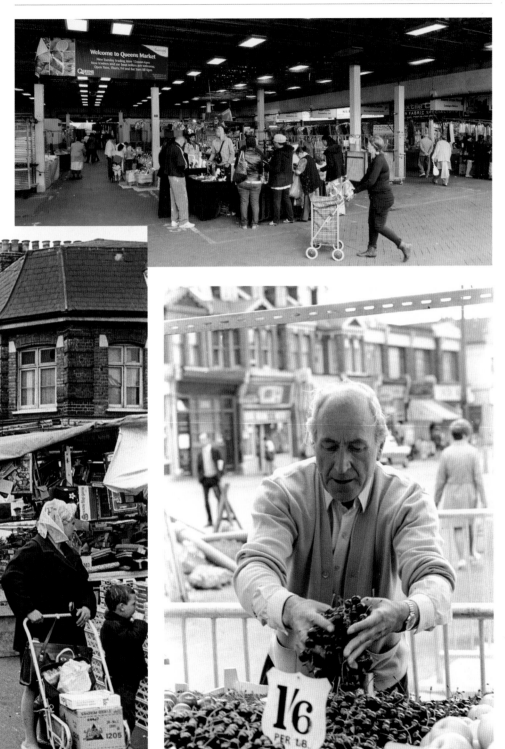

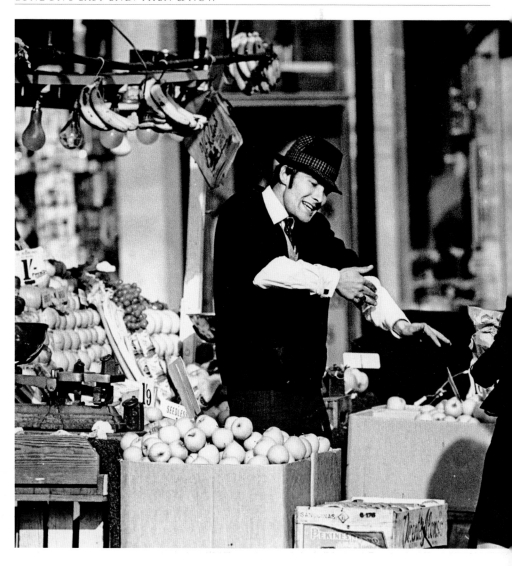

The market traders' heritage came home to me, quite literally, when I went down to the Queens Road market in Upton Park that I knew in the 1960s, and found it had gone undercover. But there was another even bigger surprise waiting for me. When I walked past the fruit stalls and got chatting to traders, one of them told me his picture was in my original East End book and even produced it from beneath his stall to show me! There he was in the photo I'd taken more than 40 years earlier – and here he was in front of me, still with the gift of the gab and charming his way through life. Barry Lightly has worked the market for 50 years and yes, at the age of 64, I can guarantee his wisecracks are as good as ever!

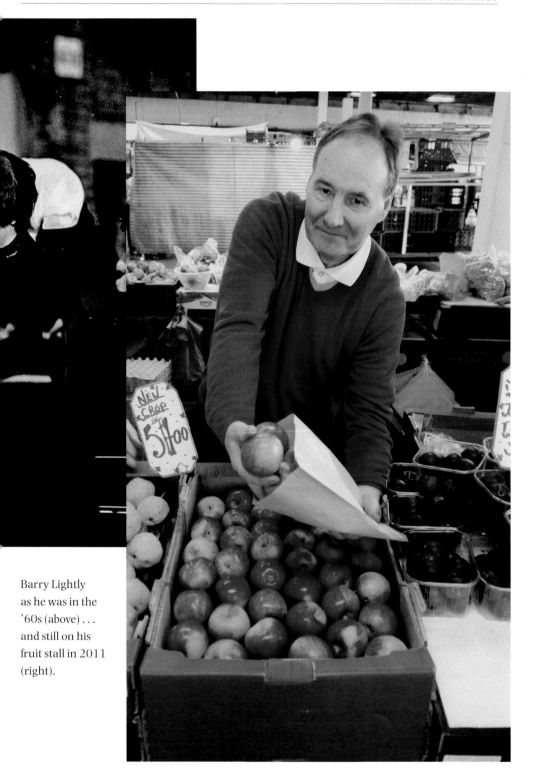

Barry Lightly as he was in the '60s (above) . . . and still on his fruit stall in 2011 (right).

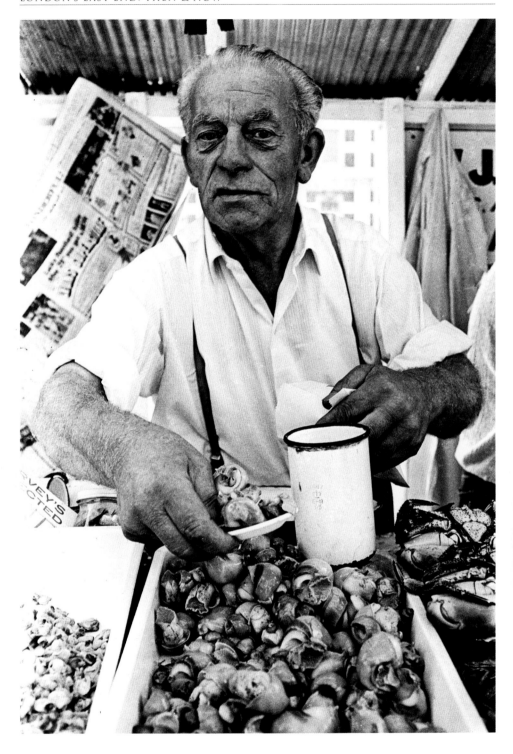

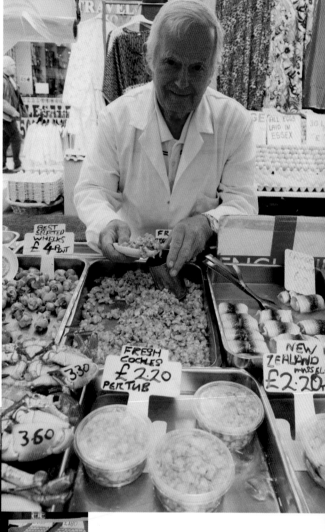

Then, at Stratford Centre I got a similar shock. Back in the 1960s, I photographed Bill Harvey on his shellfish stall in Angel Lane – and now here was his son Ron, aged 80, keeping the family business going! Ron began working for his dad 65 years ago and was delighted to see Bill's photo in my first book. And I was just as amazed to meet Ron, half a century later, on the stall which was started by his grandfather in the 1920s in Stratford Broadway.

Opposite: Bill Harvey on his fish stall in Angel Lane in the 1960s.

Above and left: Bill's son Ron on the stall, Stratford Centre, 2011.

HOUSE POINTS

DURING THE 1960s, all the administration for Newham Council took place at East Ham and Stratford town halls. Outside, there were often people queueing, desperate to get on the housing ladder. One anxious young mum left her child in a pushchair beside the Housing Department's scoreboard, which I thought was a particularly poignant picture at the time. Who knows if that family ever clocked up enough points to qualify for a council home?

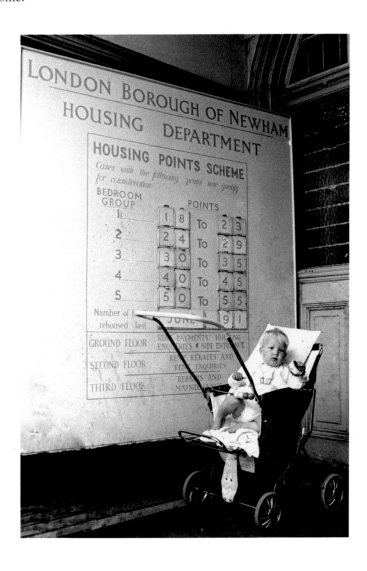

In 2010 Newham moved its council offices to what is now known as Building 1000 (below) on the old site of the Royal Docks and opposite London City Airport. It cost around £111 million and most of the work is computerised, so there's no queueing for social housing these days.

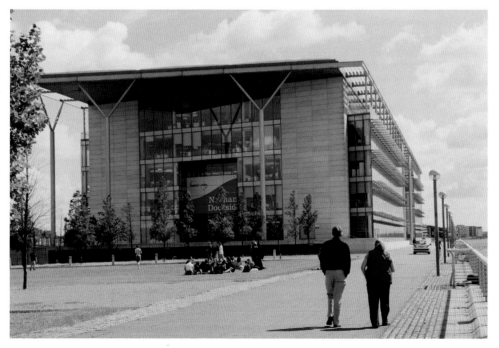

TRAVELLING LIGHT

NO ONE LIVING IN EAST LONDON after the Second World War could ever have imagined this view (opposite, top) taken from the roof of Newham Council's Building 1000. The marvellous sight of the elevated DLR train weaving its way from the centre of London through Canary Wharf to the dockside would take their breath away.

The Docklands Light Railway was opened in 1987 and made a vast difference to Londoners, reaching Stratford to the east and Lewisham to the south. And passengers alighting at Royal Albert station (opposite, bottom) definitely have a more comfortable journey than those I photographed back in the 1960s at East Ham station.

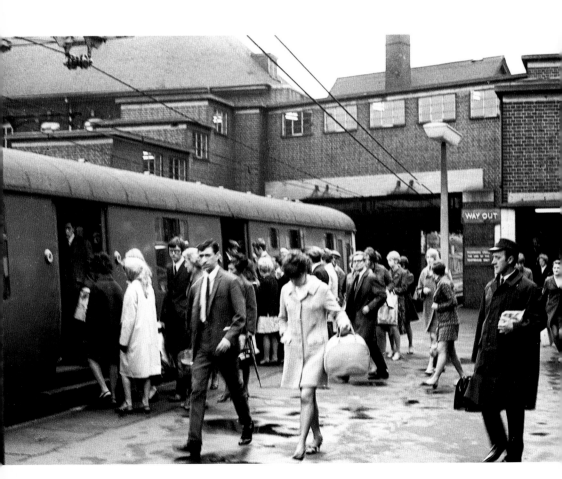

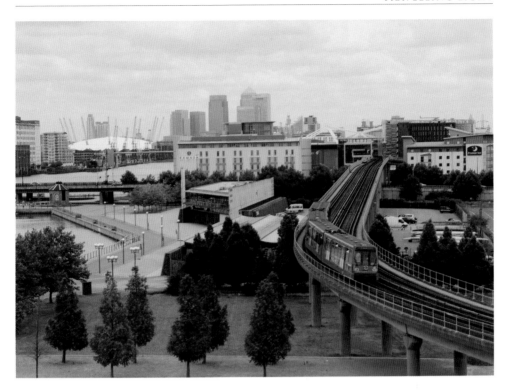

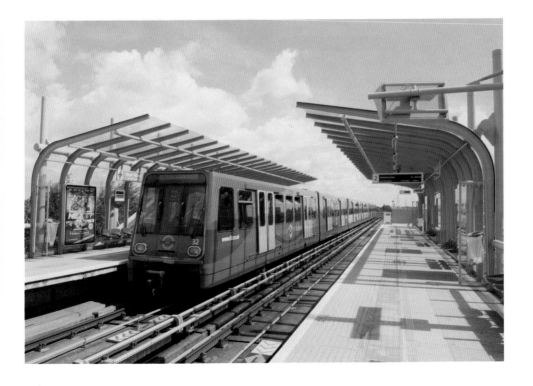

ALL CHANGE!

THE AREA NORTH OF STRATFORD HIGH STREET has undergone a remarkable transformation with the building of the Olympic Park and stadiums.

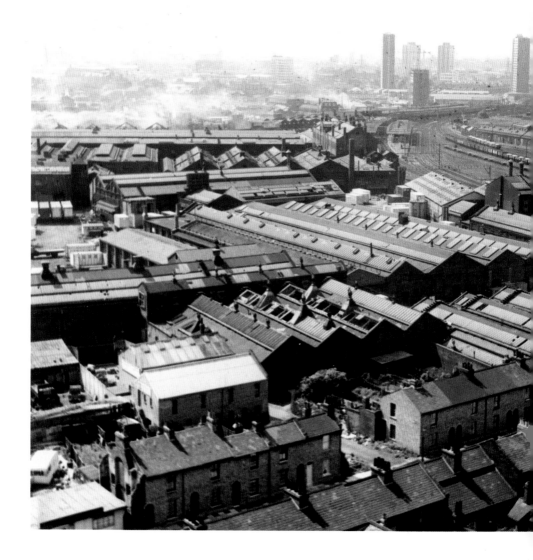

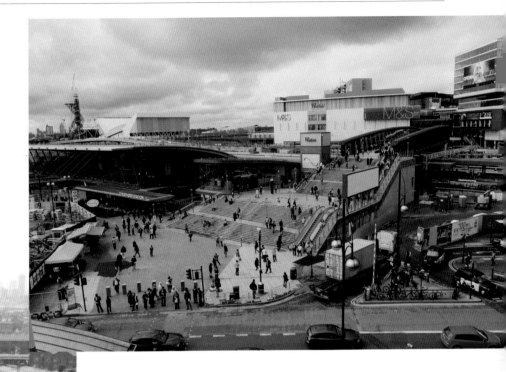

Stratford station has been completely revamped and within
half a mile is Stratford International, also on the DLR, and
transporting millions of visitors to the Olympics. In the same
complex is the £1.45 billion Westfield Centre, Europe's biggest
shopping mall which opened in 2011. As well as more than 300
shops, it has 70 restaurants, three hotels and the UK's largest
casino.

My old photograph, taken in the 1960s, shows the railway
works to the north of Stratford station, close to Angel Lane
and Temple Mills. The old railway sidings and buildings have
completely disappeared to make way for the new infrastructure
but the railway lines remain in their original position, passing
beneath the walkway leading to the shopping centre.

The complex is the main access to the Olympic Park and in my
picture taken from the top floor of Stratford Centre (above), you
can see just how compact the whole area is (see also overleaf).

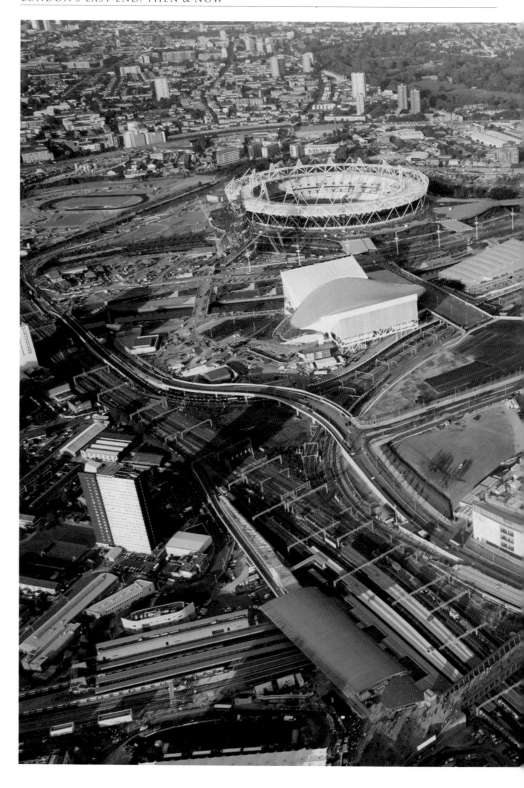

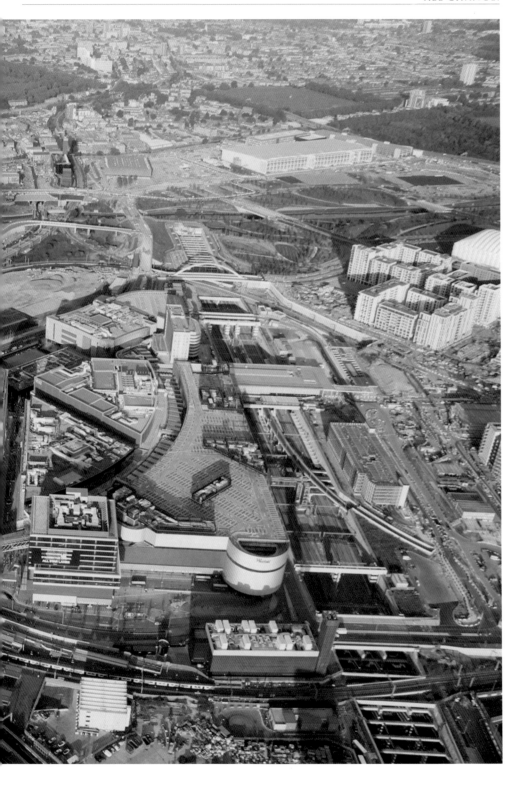

FASHIONABLE ROOTS

WHEN I PHOTOGRAPHED DAVID BAILEY for a newspaper feature, he was already
a celebrity and one of the world's top fashion photographers. He worked with (and
romanced!) some of the most famous supermodels but he never forgot his East End roots.
His family home was in Heigham Road, East Ham.

 I was a bit of a fashion photographer too, but didn't reach Bailey's giddy heights. He'd
be using top studios while I was out in a local market taking my fashion pictures.
I went down to Stratford recently to take a look at today's fashions, but I think I prefer the
hot-pants of the 1960s!

LAW AND ORDER

WHETHER THEY WERE CONTROLLING the traffic or groups of protesters, East End Bobbies in the 1960s never felt threatened or intimidated and always had the respect of the public. Today, however, policing is a very different job, as these powerful images show, taken during ugly riots in Canning Town in 2011.

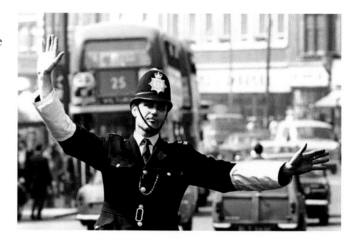

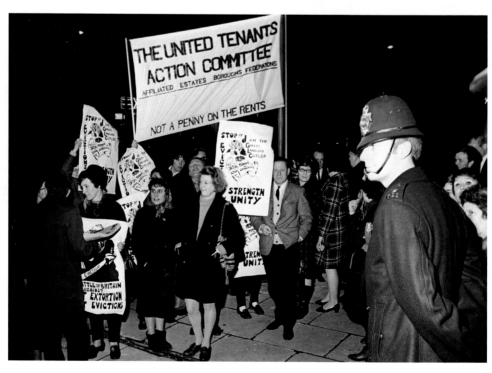

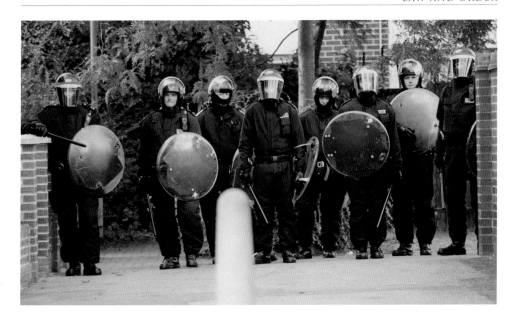

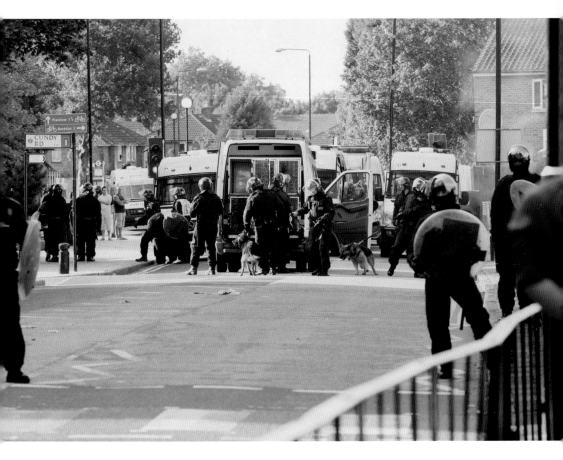

London's East End
A 1960s Album

STEVE LEWIS

978-0-7524-5486-3

The gritty reality of life in 1960s East London, in stark contrast to the pop revolution and stirrings of flower power elsewhere in the capital, is graphically illustrated here in this fine collection of photographs. Widespread poverty, poor housing, industrial unrest and racial tension were the concerns for these working-class Cockneys – and yet they had their traditions and morals, their character and resilience standing strong in the face of increasing strife. Taken in the early days of Steve Lewis' career, before he became a distinguished national newspaper photographer, see life in the East End as it used to be, the old fabric of the area now consigned to memory, long before dockland rejuvenation and Olympic stadiums.

Visit our website and discover thousands of other History Press books.

www.thehistorypress.co.uk